MY AWESOME ADVENTURE WITH THE HOLY SPIRIT

LIFE LESSONS FROM THE BIBLE'S GREATEST TOUR GUIDE

GRETCHEN M. NERO

Five
Stones
Press

CONTENTS

DEDICATION

To my Mom, Catherine Lee Nero.

You inspire me to live higher.

INTRODUCTION

My purpose in writing this book is to let you know that whatever you think of yourself, regardless of how people see you, your thoughts about you are the truth! Stand in your truth!

I was born in Lake Charles, LA, in 1961 to Catherine Lee Nero. I knew who my father was, but unfortunately, we never have had a relationship. My Mom had seven sisters and one brother, and my grandparents were both a source of constant love and joy in my life.

My Mom had a twin sister who, in my opinion, was extremely challenging at best. As a child growing up and hearing her speak to my mother, I knew something was awfully wrong in the way she treated her. I cannot imagine having someone constantly telling me that I would never amount to anything or have anything. I could clearly see that this was damaging my Mom, my spirit and my self-esteem, so at the age of twelve, I wrote my uncle a letter asking him to talk to his wife and to tell her to stop saying that my mother and I were stupid and

we would never amount to anything. Again at the age of fifteen, I wrote another letter with the same contents to him, but nothing was ever done either time.

I believe my Mom had enough, and she also couldn't handle the memory of an abortion she had about two years before I was born. When I was around ten years old, my Mom turned on me, and from then on, our pleasant memories together became few and far between. Somehow, she could only remember the good times as she got older, not the bad things she actually did and the words she said to me.

The day I was driving out to Houston, TX, in 2013, my Mom came to my house and said she had been speaking with her priest at her church, and he said she owed me an apology. My Mom's exact words were, "I apologize for anything I've done to you when you were a child because of my alcoholism. I apologize for having an affair and getting pregnant, but I don't apologize for having you." I told my Mom I forgave her, but unfortunately, her words of apology did not erase all the memories I had, even though I knew she was very sincere with her apology.

I have always known that God brought me to Houston to heal me. After my Mom passed away in 2017, it took me a year or two to actually go through her things. What impressed me most was the way she used to dress me and comb my hair and take so many pictures of me when I was a small child. Up until about the age of nine or ten, I could truly tell she was connected to me. Those pictures are proof that she really loved and cared for me.

When my mother passed away, I thanked God that we were on really good terms. About two years before she

passed away, she asked me if I ever considered being a preacher. With that one question, I knew that she really saw me. It was extremely important to me that she saw the authentic person that I am. Going on this amazing seven-year journey with the Holy Spirit from 2010 to 2017 has allowed me to truly forgive my Mom, and I know I will see her again one day, and we will both be happy and whole.

I have a friend named Jacinta Thompson whom I've known for approximately thirty years, and each time an incident would happen in my life, which in most people's opinion might be considered extraordinary, she would say, "You need to write a book!" Well, I finally wrote a book! Writing this book has taught me that my true love comes from Jesus Christ our Lord and Savior. My prayer and my hope for you is that in reading this book, you will find a desire to connect with our Lord and really listen for His direction in your life. I am wishing you connection, healing, new adventures, and curiosity as to how the Holy Spirit shows up in your daily life!

THE BEGINNING OF MY JOURNEY AND THE ENDING OF A BEAUTIFUL FRIENDSHIP

Blessed are those who mourn, for they will be comforted.
Matthew 5:4

How amazing to know that God wants to be in a personal relationship with us!

October 21, 2018. I had just made the halfway mark of my power walk around The Galleria area in Houston, TX, and was passing by Whole Foods Grocery Store. I decided not to get coffee because I was going to walk straight through and make a pot of coffee when I returned home. As I was passing Whole Foods, I kept hearing, *"Go back and have coffee. Go back and have coffee."*

It was so overwhelming that I actually turned around and walked into Whole Foods and purchased a cup of coffee and sat upstairs in the lounge for a few minutes to let it cool down so I could drink it. Since I was just sitting there, I started journaling on my cell phone about my day

and how happy I was to start walking again in The Galleria after literally not doing this for an entire year.

I began to journal, and everything just started flowing and flowing and flowing, and I ended up sitting in the lounge for two hours. I now know the reason I needed to stop at Whole Foods and sit for a moment was because I rarely sit still, and it's in the stillness that I really connect with the Holy Spirit.

In my journal, I wrote: I feel as if I am back on track, and I am extremely happy. One of my absolute favorite things to do in The Galleria is to walk the 3.1 miles starting from my front door, walking alongside the Galleria Mall, passing St. Michael's Catholic Church, stopping at Whole Foods for a cup of coffee, trying my best not to stop in Snooze AM restaurant and have the shrimp and grits, passing by the Williams Water Wall, and then arriving back home having completed all 3.1 miles. I feel accomplished! I hadn't walked for an entire year because I was in a subtle depression mourning my Mom, who passed away in October 2017.

Today is the one-year anniversary of my "New Life." I have been on an unbelievable journey the past seven years, and I know it's due to God, because I should not be here. Starting mid to late October of 2010, I told my best friend since childhood, Sharon Thompson, that I felt I needed to go to the Holy Land. I actually made a joke about it because the Holy Land wasn't on my bucket list at all! The conversation went like this:

Gretchen: Sharon, I think I need to go to the Holy Land.

Sharon: What?

Gretchen: Seriously, I really think I need to go to the Holy Land. I keep getting this strong feeling that I need to go. Oh my God, I'm so embarrassed, Jesus is not on my bucket list! It's not like I'm going to run and put Him on there now, because He knows everything and He's not on it. I want to go to Italy, take a Mediterranean cruise, and learn Spanish, but I have no desire to go to the Holy Land!

A week later, I told Sharon that I really could not shake the feeling of needing to go to the Holy Land, and she said that we really needed to pay attention to this because she had known me for thirty-five years and I had never mentioned the Holy Land before, but in the last week, I had mentioned it twice.

Sharon and I had plans to go to the movies on Saturday, November 6 to see *For Colored Girls Who Have Considered Suicide/When the Rainbow is Enuf,* but the day before (Friday), my boss was leaving the office early for the remainder of the day. I asked him if I could take a half-day vacation, and he said, "Yes." I called Sharon right away to see if we could go on Friday instead of Saturday for lunch and to an early show. Sharon agreed, and she met me at my house. We went to lunch, then on to the movies. After the movies, we hung out and talked for a couple of hours and walked in and out of the retail shops near the movie theater. We ended up sharing a pizza together for dinner, and then we headed back to my house.

Before Sharon left my house, I told her that I had uploaded the photos from the Halloween Party on my computer and I wanted her to see them. A week prior to

Sharon passing away, Alexis (a dear friend of mine), Sharon, and I had attended a Halloween party that my cousin Stephon's company had thrown, and I had taken several photos at my house before we left for the party. As the photos started appearing on my computer screen, Sharon looked at them and said, "I'm beautiful! I'm beautiful! I'm really beautiful!" I looked at Sharon and said, "Yes!" Unfortunately, Sharon had never seen herself as being a beautiful human being because of her weight, and I was overwhelmed with emotion that she had finally seen herself as I and many others had seen her, a beautiful person both inside and out!

On November 8, I was sitting at my desk, and Sharon's sister, Marcella, who lives in Bothell, WA, called me at work to let me know that Sharon was in the hospital. Sharon had been talking on the phone to her friend Oddie earlier in the day, and Oddie, who lived in Northern California while Sharon was in Los Angeles at the time, felt that something wasn't quite right. Oddie would ask Sharon a question, and Sharon would give an answer that didn't correspond to the question. When Oddie and Sharon hung up the phone with each other, Oddie dialed 911 for a welfare check on Sharon since Sharon lived alone. When the EMTs arrived at Sharon's home, she was coherent enough to let them into her apartment, but they assessed her and took her immediately to the emergency department. The hospital was approximately three miles from my job, so I left work a little early to go check on her.

At that time, there wasn't a specific reason why she

was rushed to the hospital. I arrived around 4:30 PM and went directly to where she was admitted. The nurse walked me to her bedside. By that time, she was already in a coma. She looked perfectly at peace and had a slight smile on her face. I guess seeing her smile didn't make me worry too much, and I thought that everything would be just fine. I held her hand and talked to her and told her how much I loved her. I was able to visit with her for approximately fifteen minutes and then I was escorted back to the waiting room. I was sitting with her sister Sheila, and Sheila decided to run home for a quick break since I was there.

There was a shift change shortly before 8:00 PM, and no one was allowed inside the patients' rooms. Shortly after 8:00 PM, I decided to go see Sharon again, and I walked back to the area, but the nurse would not let me back into the emergency area to see Sharon. The nurse said that only family was allowed back into the room. I was very firm with him and told him, "I am family!"

I immediately picked up my cell phone to call Marcella to have her speak with the nurse to allow me back into the room. I handed the nurse my cell phone so Marcella could speak with him, and I went to sit down until they completed their conversation. He walked over to me and stood directly in front of me. My first thought was, *Personal space, please!* He handed me the cell phone, and this was the conversation:

Marcella: Gretchen, Sharon's gone.

Gretchen: No, she's not. I've been here the whole time, and she didn't leave.

Marcella: Gretchen, Sharon's gone.

THEN I KNEW why the nurse was so physically close to me. It was then that I realized that Sharon had passed away. I dropped my cell phone and collapsed into his arms, and I cried and cried and cried!

A month prior to Sharon passing away, she had been bitten on her baby finger to the point that the fingernail was ripped off by a rescue dog she was fostering, and she went to Emergency to get the wound stitched up. Somehow during that time, she contracted MRSA and her cause of death was septic shock. My heart broke! There was no indication on Friday when we had gone to the movies that she was even sick. She had slight flu symptoms but was determined to go. I am so grateful she made the decision to go with me, because we had such a great time out together and laughed and joked the entire evening.

Needless to say, I walked blindly through the remainder of the year with no passion for life at all. Not only was Sharon my best friend, but she was my sister, my ride-or-die girl, my therapist, my please-shut-up-for-a-moment-so-I-can-stop-laughing-because-my-side-literally-hurts friend, my oh-my-God-I'm-so-sad-let's-eat-pizza-and-cupcakes-together girl, my staunch supporter, my angel on Earth, my very best friend. My prayer for everyone is to experience a Sharon in their lifetime.

LESSON LEARNED: I worked hard at not being sad all the time because Sharon was one of the happiest people I knew, and I know she would not have wanted me to miss out on all the good that God has planned for me. I learned that even though she passed away and it really hurt, I would not have changed a thing to have an opportunity to experience her as a friend in my lifetime.

NEW LIFE MINISTRIES

Because you have these blessings, do your best to add these things to your lives; to your faith, add goodness; and to your goodness, add knowledge; and to your knowledge, add self-control; and to your self-control, add patience; and to your patience, add service for God; and to your service for God, add kindness for your brothers and sisters in Christ; and to this kindness, add love. If all these things are in you and are growing, they will help you to be useful and productive in your knowledge of our Lord Jesus Christ.

2 Peter 1:5-8

❧

At the beginning of 2010, I was given the gift of discovering New Life Ministries in Laguna Beach, CA. I had gone up to one of the suites (I was managing a commercial building at the time in Century City, CA) to see Jaime, who was the assistant to

one of my new tenants. When I walked through the door, there was a bookshelf immediately to the right of the door. On the bookshelf were several books by Dr. Henry Cloud and Dr. John Townsend, including one titled *Boundaries*. I said, "Hey, Jaime, that's a really good book!"

Jaime looked at me a little funny and said, "You know Henry wrote that book."

I asked, "Who is Henry?"

When I rented the suite to Henry and Jaime the prior month, the lease was under William Henry Cloud, and I had no idea that William was Henry the author. Jaime and I just started laughing! Shortly thereafter, Jaime made me aware that Henry's birthday was coming up, and I told her I would bake him a cake. The day of Henry's birthday, I baked him a pineapple cream cheese cake and brought it to his office. Henry was on his way out the door, and he said, "Gretchen, listen to me on the radio, and I'll mention your cake!"

I replied, "You're on the radio?"

He started laughing and said, "Yes, listen at 2:00 PM on KKLA."

I went to the park near my office that day, and sure enough, Henry was on the radio. That's when I discovered New Life Ministries. Best discovery ever! Henry did thank me on the air, and each day thereafter, I took my lunch at 2:00 PM so I could drive to the park and listen to the radio program.

Steve Arterburn, Founder, was the host, and a few of the cohosts at that time were Dr. Henry Cloud, Dr. John Townsend, Dr. Jill Hubbard, Dr. Sheri Keffer, Dr. Dave Stoop, and Milan Yerkovich. This radio program literally

saved my life and gave me the guidance I needed at that time. Listening to the questions from the callers and the responses from the host and cohosts helped me solve a lot of the issues I was dealing with, and I loved the fact that it was a Christian-based program. It was through New Life Ministries that I learned of the upcoming trip to the Holy Land and that their ministry was going in June 2011.

LESSON LEARNED: New Life Ministries was a great source in helping me to rebuild my faith foundation. Getting to know their ministry taught me the importance of being planted in good soil.

JESUS CHRIST FAITH CENTER CHURCH

*Before you know it, a sense of God's wholeness, everything
coming together for good, will come and settle you down. It's
wonderful what happens when Christ displaces worry at the
center of your life.*
Philippians 4:7

In early December 2010, my God sister, Dolores
Hill, dropped a book by my office titled *It's Bigger
Than You: But Just Right for God* by Mattie Burnett
Bobo. The book centers around the profound love that
God has for all of us. Mattie Bobo is the first lady of a
church in Los Angeles called Jesus Christ Faith Center. I
asked Delores if Mattie Bobo, known as First Lady Bobo,
ever preached and she said she did on the first Sunday of
each month. I asked Delores if I could go to church with
her the next time the First Lady spoke, and Delores said,
"Yes."

During that conversation, Delores asked if I wanted to go to Christmas dinner at her friend Sedie Avakean's home. I told her I wasn't sure because I was feeling really sad and depressed, but I would let her know, and if I told her yes, I would definitely stick to my yes and not flake out on her at the last minute. I did attend Christmas dinner with Delores at Sedie's home, and it was an intimate family dinner that was amazingly warm and inviting.

When I walked into Sedie's home, there was a piece of art that had several different crosses in various sizes inside the frame. I commented on how beautiful the piece of art was, and Sedie said she had purchased it in the Holy Land. I mentioned to Sedie that it was ironic because I kept getting a strong feeling that I should go to the Holy Land. Sedie said, "You should go because you are being called."

I had absolutely no clue what she was talking about, and I told her I didn't have the money at that time to go to the Holy Land. She told me to try because it was important.

The first Sunday in 2011 was January 2, and I attended Jesus Christ Faith Center church with Delores to hear First Lady Mattie Bobo preach. The sermon was uplifting, amazing, and inspiring! After the sermon, people started going up to the front of the sanctuary, and I saw the ushers holding these medium-sized cranberry-colored blankets. I asked Dolores about the meaning of the blankets, and she explained to me that when you are slain under the Holy Spirit, you literally pass out, and the ushers cover you up with the blanket.

Growing up as a Catholic, I had never heard nor experienced what she was speaking of. It was completely foreign to me. Delores suggested that I go up for prayer, and I politely said, "No, thank you."

Moments later, Sedie, who is also a member of the church, walked up to me and whispered, "You should go up for prayer and pray for the funds to go to the Holy Land." I thought that was a good idea, so I got up out of my seat and went to the front of the sanctuary to ask for prayer.

First Lady Bobo started to pray over me and anointed my forehead with oil. At one point, my right foot felt a little weak. I tried to balance myself and straightened out my feet so I would not fall. I wasn't quite sure what was happening at the time, but within seconds, I felt my whole body go limp. I passed out, and the next thing I knew, I was lying on the floor. I felt someone put a blanket over me. I tried with all my might to get up, but I literally could not lift my shoulders, arms, or legs. I couldn't open my eyes and I could not speak, which was really freaking me out, and after several attempts, I just surrendered and lay there.

The sound in the room went to complete silence, and then I heard a beautiful harp slowly start to play, and a soft gentle voice said to me, "You are significant, and I'm going to make you anew. You are significant, and I'm going to make you anew. You are significant, and I'm going to make you anew." Then the voice went silent and the harp continued to play and gently faded away into complete quietness.

. . .

IT WAS a few minutes after the music faded away that I was able to get up and walk back to my seat. I noticed Dolores staring at me with an unusual look, but I didn't question it at the time. I excitedly said to her, "I want to buy that CD that says 'You are significant, and I'm going to make you anew. You are significant, and I'm going to make you anew. You are significant, and I'm going to make you anew.' The one with the harps playing."

Dolores stared at me with a strange expression and said, "We don't play music during this time."

At that moment, I relaxed back into my seat because I knew something unexplainable and special had just happened to me. Delores asked if I was okay, and I said, "Yes. Why?"

She said, "Because you were out a long time, and I was getting worried."

Delores has been a member of this church for over thirty years, and for her to get worried, it worried me. I honestly cannot tell you how long I was slain under the Holy Spirit. Time felt as if it were suspended, and it could have been two minutes, ten minutes, or even twenty-eight minutes, I sincerely do not know the answer to that question.

LESSON LEARNED: I've learned the importance of surrendering. Most times, we continue to go against the grain and life gets unnecessarily difficult for us. If we learn to surrender ourselves to God, He will guide us.

AN ANGEL AND MY ANGELS

Ask, and God will give to you. Search, and you will find. Knock,
and the door will open for you. Yes, everyone who asks will
receive. Everyone who searches will find. And everyone who
knocks will have the door opened.
Matthew 7:7-8

January 18, 2011. I was at work, it was near 5:00 PM, and everyone else had already left the office for the day. I had gone to the ladies' room, and on my way back, I came through the back door to make sure every door was locked before I left the office. I was taking a short cut through the copy room, but as I started to walk in that direction, my breathing grew labored, and it scared me to death since I was the only person in the office. I started to walk toward the back door, and my breathing got better. I found that utterly confusing and alarming.

Since I didn't want to experience that again, I decided to go all the way around the office. I know this makes no sense, but I thought if I were to pass out, at least I would pass out on carpet and not the linoleum flooring in the copy room. That route took me past my boss's office, which sat directly in the corner. As I was walking toward his office, my breathing was perfectly fine. Weird. As I passed his office, I looked in and saw a pulsating figure in the horizontal blinds. It was a brilliant white, and even though the blinds were horizontal, a complete figure appeared. I ran down to my desk, grabbed my cell phone, and came back and took a picture. I looked all around the room to see what figure could have made a reflection of that shape, and there was absolutely nothing in his office. I looked out the window, and there was nothing there as well.

Our office was on the ninth floor, and the parking structure across the street was only four stories high, so there was a completely unobstructed view from that vantage point. I went back to my desk and sat there quietly and thought about what had just happened. I made myself a promise not to tell anyone because I knew no one would believe me. I just kept staring at the brilliant figure on my cell phone.

Later that night, I was attending a play at the Pantages Theatre, and shortly before the play started, I heard my cell phone vibrating again and again in my purse. I looked down to turn the cell phone off and I noticed it was Sharon's sister, Marcella Thompson, calling me. I turned the cell phone off and enjoyed the play.

. . .

THE NEXT DAY, I called Marcella back, and she asked me to go to a private office, since I was at work, so we could speak. I went to the library and closed the door. Marcella asked me how I was coming along with my trip to the Holy Land. I wasn't quite sure how she knew about my trip because we had never discussed it before. I

'm not sure if Sharon had mentioned it during one of their conversations before Sharon passed away, but that's highly doubtful. Marcella lives in Bothell, WA, and at that time, I was living in Los Angeles, CA. After Sharon's memorial service in November 2010, Marcella and I didn't have a chance to speak much about personal things because we were in the midst of the undertaking of cleaning out Sharon's apartment and planning her service. When Marcella and I continued the conversation, I apologized to her and said I saw she had called, but I was at a play and it literally was just about to start.

Marcella said the previous evening, she was walking down the hall in her apartment and Sharon came to her and said, *"Pay for Gretchen's trip to the Holy Land."* Marcella then called her sisters Sheila Thompson, Mylea Thompson, and Marlene Thompson to discuss with them what had transpired. During the conversation, Marcella told me that they were all in agreement and she was going to send me $1,000, Sheila was going to send me $1,000, Mylea was going to send me $1,000, and Marlene was sending me $500.

Marcella asked if that would cover my trip, and I mentioned the trip was $3,200 and it was all-inclusive. I went silent on the telephone. My mind couldn't wrap around what just happened. Their generosity was over-

whelming! One by one, the checks arrived at my home over the next couple of weeks, and I was able to pay for my trip to the Holy Land with New Life Ministries.

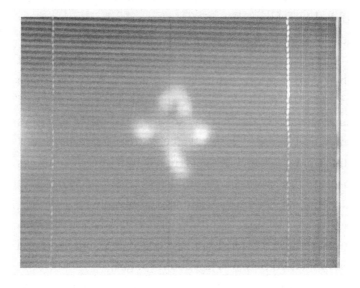

~

LESSON LEARNED: I went up for prayer at Jesus Christ Faith Center Church to be able to go to the Holy Land, and God answered my prayer. I will always pray with expectancy!

THE HOLY LAND WITH NEW LIFE
MINISTRIES

*"If anyone believes in me, rivers of living water will flow out
from that person's heart, as the Scriptures says." Jesus was
talking about the Holy Spirit. The Spirit had not yet been given,
because Jesus had not yet been raised to glory. But later, those
who believed in Jesus would receive the Spirit.*
John 7:38-39

I prepared myself for the trip, which was in June 2011, and I did not know what to expect since I had never desired to go to the Holy Land. What I did know is that I have always loved Jesus and have always felt His presence around me. What I didn't know is that I was able to have a personal relationship with Him. I was taught that I had to go to my priest to ask him what I wanted to ask God and also to ask the priest for forgiveness for my sins.

. . .

I WAS GIVEN a penance to say, and that was it. It never made sense to me, but as a child, I never questioned why it was done that way. I simply viewed God, Jesus, and church through the same lenses as my Mom. As I got older, my faith was becoming a generational relationship rather than a personal relationship with God, and I began to question if that was the way I wanted to experience faith.

When I arrived in Tel Aviv, Israel on June 6, 2011, it is difficult to describe, but I felt as if I had arrived home! The presence of love surrounded me in Israel. The baptism at the Jordan River was scheduled on the fourth day of our tour, and I had signed up to get baptized. My Mom had me baptized as a baby, but as an adult, I wanted to renew my commitment to God, and I thought this would be an amazing experience. As I walked down the steps and into the Jordan River toward Steve Arterburn, who was performing the baptism, I was a little nervous. I'm not quite sure why, but the moment felt very special. I was submerged in the Jordan River, and as I came out, it felt, starting from the tip of my nose, as if I had been wrapped tightly in cellophane and all the cellophane was shedding off of me and falling into the Jordan River. Every sense of my being felt as if it was brand-new and I was walking out of an old life and into a brand-new life. I had never really understood what it meant to be "born again," but now I have a much better understanding of what it means.

During the remainder of my journey in Israel, I went on to experience praying in the Garden of Gethsemane, going to Bethlehem, and touching the Silver Star where

Jesus was born, walking the Via Dolorosa, praying at the Western Wall, and many other life-changing experiences. When I returned home to Los Angeles, my external daily life was the same, but my internal life was completely different. I could feel that something had shifted in my spirit. My spirit was more sensitive and aware to what was happening in me and around me.

LESSON LEARNED: As a Christian, going to the Holy Land really brings the Bible to life and made me interested in reading my Bible more. Growing up, there was always a Bible in our home, but we did not read it on a regular basis. It seemed to me that going to church was the way the Bible was explained to us. I never was encouraged by our church to actually read the Bible myself.

A WHISPER TO OBEDIENCE AND CONNECTION

I also gave them this command: Obey me, and I will be your
God and you will be my people. Do all that I command so that
good things will happen to you.
Jeremiah 7:23

The lesson I've learned about being obedient is that you are being used by the Holy Spirit to bring happiness, protection, or insight, to help someone, to inspire someone, or to encourage someone, or to give them whatever guidance they need at that moment. The more I'm obedient, the more I see the importance of following through because the results are always for good. I'm going to speak of a few of the many requests I've been privileged to participate in because these in particular are dear to my heart because of the outcome.

Request One:

Shortly after returning from the Holy Land in July of 2011, I was getting extremely excited about attending the Hollywood Bowl and sitting in the Pool Circle Box for the Smooth Jazz Concert because I would be turning fifty years old in August, and the concert was two weeks before my "Big 50." I was deciding which three friends I would take, and we would have cake and champagne and just have a blast for the Big 50! I had my plan; God had His plan. He won! About a week later, early one morning, I was walking down the hallway in my home, and I heard the Holy Spirit say, *"Take Minnie and her family to The Hollywood Bowl."* What? No! It's my Big 50! Focus on me! I barely know Minnie!

I had met Minnie and her daughter Ashley in February of 2011 at a health class at my church I was participating in, and we struck up a friendship, but hadn't had the opportunity to hang out together. Therefore, it was confusing to me as to why the Holy Spirit would ask me to take them. I must admit, I wasn't thrilled about being obedient, but it felt as if it were a constant gentle tapping on my shoulder, and the only way for the tapping to stop was for me to just surrender and be obedient.

I text Minnie to invite her, her husband, and her daughter Ashley, and Minnie texted me back saying that she would love to go. Minnie had been to the Hollywood Bowl before, but her husband and her daughter had never been. The next day, Minnie texted me, asking if she could drive her vehicle because it was set up for her husband Michael's wheelchair. "Wheelchair?" I asked. Minnie said

that Michael had cancer, and due to his cancer, his leg had been amputated from the knees down and he was in a wheelchair. I told Minnie I would call the Hollywood Bowl to remove one of the chairs in our box, and we could easily accommodate Michael and his wheelchair. As soon as we made arrangements for the event, the gentle tapping went away!

August 14, 2011. Minnie, Michael, Ashley, and I went to the Hollywood Bowl and had an amazing time. Minnie sent me a card, and it read: *Gretchen, your thoughtfulness reflects God's love. Ashley, Michael, and I want you to know we had the time of our lives and sincerely appreciate you and the kind thoughtfulness you showed us with the Rose Bowl concert treat!*

I didn't realize at the time I had invited them to the Hollywood Bowl it would be their first time going together as a family. During the concert, I had taken plenty of photos, and about a month later, I made a Shutterfly book of the photos for them and mailed it to Minnie. A few months had passed, and I didn't remember hearing back from Minnie, so I texted her asking if she had received the book and how everything was going.

Minnie text back saying Michael had passed away and how much the evening at the Hollywood Bowl had meant to them. I was speechless, sad, shocked, but unbelievably grateful that the Holy Spirit used me to host a beautiful evening for Minnie and her family.

Request Two:

In January 2015, I was getting very excited to have my first three-day weekend of the year. I was sitting at my desk on Wednesday, January 14, 2015, and I heard the Holy Spirit say, *"Go pick up BJ."* My response was, "No! It's my first three-day weekend, and I want to be totally selfish and relax the entire weekend!"

BJ is my young cousin who lived in Lakes Charles, LA and was twelve years old at the time. BJ would come to Houston one weekend a month to explore Houston. He had just come to Houston a couple of weeks prior, so it wasn't time for him to return. I kept hearing *"Go pick up BJ"* over and over again, and I reluctantly texted his Mom asking if he could come out for the weekend. She said, "Of course, you know BJ wants to go!"

The next day, I drove to Baytown, TX to meet his parents, Stephanie and Paul, and to pick up BJ. On the drive back to my home, I said to him, "God must really love you, because I totally have plans, but somehow you must need to be at my house this weekend." Like a typical twelve-year-old, he just stared at me and didn't say a word.

On Saturday, we decided to go to the movies, and afterward, we headed to the grocery store to get a few items. As soon as we parked at the grocery store, I looked at my cell phone and noticed I had several missed calls from Stephanie. I decided to call her back, but I waited until I turned the car off so that the Bluetooth would disconnect just in case there was some bad news that she didn't want BJ to hear. When I called Stephanie, she said,

"Hey, Paul's parents' house burned down early this morning, and BJ was planning on staying there the entire weekend. Everyone made it out of the house fine. Thank you for getting my child."

I guess the look on my face really frightened BJ! I hung up the phone with his Mom and told him what had happened, but that everyone was perfectly fine, and BJ said, "I guess God really does love me!"

Request Three:

In May of 2018, I felt this overwhelming push to sell my home in Los Angeles. I absolutely knew it was the Holy Spirit because not one percent of me wanted to sell my home! I loved everything about that little yellow house on Redondo Blvd. in Baldwin Vista. I loved my home, the size of the property, my friends and family who lived nearby, my amazing neighbors.

I was centrally located to everything, and I had the annual Easter dinner at my home, which was my favorite event of the year! But the feeling would not go away, and I knew that I just needed to surrender and be obedient. Mid-July, I flew to Los Angeles to meet with Dominique Brown, my real estate agent. We did everything to get the property and home in selling shape, and on August 2, 2018, my home was officially on the market to sell. I noticed something that didn't seem quite right, so I called Dominique to ask her about my MLS number. I knew the first two numbers represent the year the house was placed on the market, and I assumed the remaining numbers were randomly assigned by the computer.

I was intrigued because I have a history with the number 18. I have always had a favorite number, and it is 8. A few years ago, I started to notice that whenever the number 18 showed up, something especially spiritual and very cool would happen, so I just chalked it up to God doing something special. He's number 1, and next to my favorite number 8 you have "18." When I saw my MLS as being 18-371818 I was shocked, excited, and intrigued to say the least!

On August 6, 2018, I had my first offer. That offer didn't go through, but on August 29, I had another offer, and the first offer came back, so then I had a bidding war. I was finally in escrow with the second offer in early September. Escrow was coming along just fine...or so I thought. By the end of September, we couldn't agree on the terms, so escrow was canceled. I wasn't discouraged because each time something happened, another offer came in almost immediately. On October 8, I had another offer, and we went into escrow only to fall out of escrow four days before close of escrow. January 4, 2019, a contingency offer came in, which I turned down. At this point, I was frustrated and confused and could not figure out what I was doing wrong. I began to just be still and pray and wait for direction.

On Sunday, March 3, before I went to bed, I received an email from Dominque suggesting that I drop the price by $20,000. I quickly responded and said, "Yes," and asked her to send me the updated paperwork for me to sign.

On Monday, March 4, as I was getting out of bed, I heard the Holy Spirit say, *"Ask for a raise."* This wasn't something new that I had heard. I had known for years

that I deserved a raise, but I hadn't asked for one nor did I follow through from the same request I heard back in June of 2012. Disobedience. Later in the day, I spoke with my boss and requested a raise, and he kindly gave me what I asked for, but more! This one really hurts because out of my disobedience, I was the one who lost out on seven years of a raise. Lesson learned! When the Holy Spirit tells me to do something now, all I say is, "Yes, sir!"

Immediately after I hung up the phone with my boss, I headed out to grab some lunch. I had just received my food when my cell phone rang, and it was Dominique. I immediately asked her, "Hey, where's the paperwork for me to sign?"

She said, "You won't believe this. I was filling out the paperwork to reduce the price for you to sign, and a friend of mine who is a real estate agent called me and said, 'Hey, what's happening with the yellow house on Redondo Blvd.?' I told him I was just about to reduce the price, and he said, 'No, don't do that! My client looked at the house in August, but it was already in escrow. His wife wants this house! He loves to bargain, so keep the price the same!'"

I just fell out laughing! Dominique told me her friend said that shortly before the couple left to go out of town, the wife was passing by the house and noticed the For Sale sign was still in the front yard, so she asked her husband to inquire about the house. He did inquire and learned the house was back on the market. They were coming back in town and wanted to make an appointment to see the house on March 7. The couple made an offer on March 11, we were in escrow on March 12, and I

left on March 15 to go to Israel with New Life Ministries (my second time to Israel with New Life).

It was ironic that the scheduled day for the baptism at the Jordan River was on March 18. I got baptized again on March 18, and while I was in Israel, my agent, Dominique, called and asked if I would mind if escrow closed early because everything was taken care of and I was already completely moved out of the house. I agreed. I got baptized on March 18, escrow closed 18 days after I got baptized, and I owned my home for 18 years. 18-371818. The moment I was obedient, God put everything in motion. I've clearly learned my lesson on obedience!

Connection:

This last story isn't about obedience, but more about "connection." Connection to our loved ones. July 14, 2017, I called Mike Fourticq (my boss) on his cell phone because I needed to speak with him before his board meeting. I called him from my home to try to catch him before the meeting, which started at 9:00 AM. He wasn't available, and he didn't call me back immediately.

I went to work and saw that the message light on my telephone was blinking, indicating that I had a voicemail. I assumed it was Mike calling me back, so I immediately checked the voicemail. The prompter said, "Your mailbox is full, please delete saved messages."

My first thought was, "It can't be full. I don't save any messages on the main line at all."

I had three new voicemail messages, which was shocking because I had been working out of the Houston

office for nearly five years and the main line hardly ever rang because everyone has their own direct line. I was still using my Los Angeles extension, so I would check it daily for messages. There were three of the exact same message, which was a recording of an ongoing conference call.

I listened carefully and didn't recognize anyone's voice and found it quite strange, because when our employees participate in a conference call, we have to dial into the call and push a passcode to get connected. I listened carefully to all three messages for a minute or so, but none of the calls had anything to do with our Company or any of our portfolio companies. Somehow, the conference call dialed our number three separate times and was able to leave a voicemail on the reception area phone.

I couldn't figure this out because our system was set up to leave messages on my coworker's voicemail, and he would constantly forward the messages to me. The system wasn't originally set up to default to the reception area because the office at that time didn't have a receptionist or secretary.

I decided to check all the saved voicemails so I could delete them since the system advised me that my mailbox was full. The very first saved voicemail was from August 5, 2015, and it was from Mike Fourticq's brother, Greg Fourticq. Greg had left me some information on an upcoming fishing trip to Alaska that Mike and Greg were going to take together with four other family members. Shortly after that fishing trip, on September 18, 2015, Greg unexpectedly passed away.

. . .

A FEW MINUTES LATER, Mike had returned my call from earlier that morning, and I told him about the voicemail from Greg. The telephone went silent, and shortly after, Mike said, "Save that voicemail." I told Mike that Greg was probably trying to connect with him to wish him a happy birthday since that day was Mike's birthday. I told him how blessed he was, because I would have given anything to hear Sharon's voice just one more time, and now he got to hear Greg's voice again.

Sense of Humor.

In July of 2011 Pam Lewis and I had gone to Mammoth Lakes, CA, for the weekend to relax. While we were there, we were talking about relationships and children. On the way home from Mammoth Lakes back to Los Angeles, we were specifically talking about whether I would still want to birth children. At that time, I was already fifty years old!

The drive from Mammoth Lakes to Los Angeles is approximately five hours, and halfway home, I had to go to the restroom. I decided to take the next exit off the freeway and stop at a gas station. I got off the freeway, made a left onto the street where the gas station was located, and I had to make a U-turn to get back to the gas station.

As soon as I went to make the U-turn, I saw a police car hiding behind a small wall. Seeing how the U-turn was going to be an illegal U-turn, I laughed and said to Pam, "Guess I'm not making a U-turn." Therefore, I had to

keep driving straight, and when I got to the first stop sign, there was this HUGE sign in a completely desolate lot.

No church... Nothing was around...at all! Pam and I looked to the left, then to the right, then down the street...and there was nothing, just the HUGE sign. Needless to say, I was speechless. Pam looked at me, and I looked at Pam, and I said, "Do you think God heard us talking?"

Pam said, "Yeah."

Of course, I grabbed my camera and took a picture. We went back to the gas station, used the restroom, and were quiet for quite a while. I think we both were absorbing what had just happened.

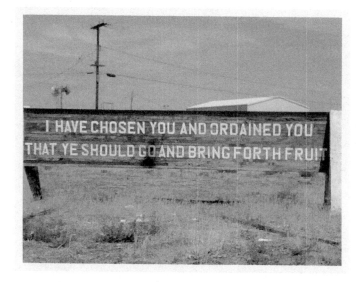

LESSON LEARNED: Most of the time I was resistant to the request of the Holy Spirit, but I have learned that being obedient has always brought me great joy and joy to the person receiving the blessing!

A NEW PLAN

The Lord says, "I will make you wise and show you where to go.
I will guide you and watch over you."
Psalm 32:8

The remainder of the year and into early 2012 after Sharon passed away, I was living on automatic pilot because I was really missing Sharon. It felt like there was a "pause" on my life, and I was waiting for someone to push Play again because I didn't have the wherewithal to push the button myself. I was basically living day in, day out, with no authentic joy.

In November 2012 someone pushed Play. It was more like he pushed Play and Fast-Forward at the same time! Michael Fourticq (my boss) asked me to go to Houston, TX, with him to continue working for him out of our Houston branch office. At that time, I had been working with Mike for fifteen years. I immediately said, "Yes!"

I believe I was super excited because I had lived in Los Angeles for forty-five years, and I've always wanted to live in another state for at least one year. It was a bucket list item that I finally was going to get to fulfill without having to sell my home or change jobs, and it was the biggest and most unlikely item on my bucket list that I would get to check off.

Initially, the time in Houston was going to be for one to two years to work on a project, and then we were going to return to the Los Angeles office. But, God had a new plan! A plan that I didn't know anything about and probably wouldn't have agreed to in the beginning. There's a popular saying that goes, "If you want to make God laugh, tell Him about your plans." That statement was now set in full motion, and I was completely unaware of how the next few years would unfold in my life.

I flew to Houston, TX, mid-December to search for an apartment, and on the second day, I found a nice apartment in The Galleria area about a mile away from our office. I spent Christmas in Los Angeles, and during the later part of January 2013, I packed up my car and Lynn Feiga, a friend of mine, drove with me to Houston.

I was adjusting nicely to our Houston office and saw Houston as a "big adventure," so I definitely was not going to sell my home in Los Angeles and set roots down in Houston. I wholeheartedly gave a 100% commitment to exploring, traveling, tasting, and experiencing all of Houston and the surrounding area because I was certain I only had two years to live there.

. . .

ONE OF MY most treasured experiences was to get to attend Lakewood Church on a regular basis. I didn't realize, at the time, when I picked out my apartment that the Church was less than two miles from my home. Going to Lakewood and hearing all the positive and inspiring messages gave me a desire to study the Word more, so I also started attending the Monday Night Bible Study. Lakewood Church has made me love attending Church again!

~

LESSON LEARNED: Be flexible! Pray BIG because God has BIGGER.

IT'S NOT YOUR TIME

Save me, O God, for the waters have risen up to my neck.
Psalm 69:1

On September 18, 2014, there was nothing but joy, laughter, and contentment in my heart. I had a wonderful three-day visit with Mom Bobo (First Lady Mattie Bobo), who had come to Houston from Los Angeles for a visit. She arrived in Houston on September 16, and we immediately started to explore the city. We did everything from discovering a new pie shop, having dinner at Ouisie's Table, breakfast at The Breakfast Klub, lunch in The Woodlands, all in three days!

While in The Woodlands, I took Mom Bobo for a walk along the Waterway, and we stopped so I could take a few pictures of her. She was standing near a water fountain, and after I took a few pictures, I asked her to step to the

side so I could take a picture of just the fountain itself. I'm sure it sounded strange to her that I wanted her out of the picture, but I heard a whisper telling me to "Take a picture just of the fountain." At the time, it made absolutely no sense to me, but I simply took the picture.

Later that evening, we were back at my apartment, and I was on my computer uploading all the pictures we'd taken and was in the middle of making her a Shutterfly book of her adventures in Houston. When I got to the picture of just the fountain, I stared at it for a moment because it seemed different to me. It didn't look like water. I continued working on the book, and when it was completed, I called Mom Bobo over to my computer to view the book on the screen to see if she wanted to make any changes. I was turning the pages of the book very slowly, and when we got to the page that had the "different" picture on it, Mom Bobo said, "That picture looks different."

I loudly and excitedly said, "Oh my goodness! That's the same thing I thought!"

Mom Bobo said, "It looks like a bride."

I said, "Mom Bobo, don't be trying to get me married!"

We both laughed and continued to look at the picture. She pointed out how the figure looked like it was wearing a gown and had a crown on top. I told her I clearly saw something that looked like a long gown and how some brides wore a tiara for their wedding, and a tiara can look a lot like a crown. Then, as I stared at the picture, I said to Mom Bobo, "That's Jesus."

Mom Bobo said, "What?"

I said, "That's Jesus."

. . .

OF COURSE, there was an awkward pause, then silence until I said, "Mom Bobo, I don't mean you any disrespect, especially since you are the First Lady of a church, but that's Jesus. We have to agree to disagree."

No other words were spoken about that picture. We continued to peruse the pages of the Shutterfly book, and I completed the book for her.

The next morning, I had to take Mom Bobo to the airport, and on the way, I decided to stop by a cupcake shop so we could get cupcakes before she left. After we purchased the cupcakes, we decided to sit in the car to eat them since we were going directly to the airport from there. While we were eating, Mom Bobo said, "I still can't get that picture out of my mind."

I said, "Oh my goodness, I was just thinking the same thing!" I went on to tell Mom Bobo how one of the ways I connect with the Holy Spirit is through pictures. We finished our cupcakes and headed to Hobby Airport.

I had taken a half day off work, and, after dropping her off at the airport, I headed back to The Galleria area, which is approximately fifteen minutes from the airport. It was slightly drizzling, by Houston's standards, and as I got off the 610 Freeway at Exit 7 (Westpark Drive), I was going in the flow of traffic and was following a small truck in the left lane, and in the right lane, there was a minivan. There was a constant flow of traffic behind me as well.

As I followed the truck and minivan into the under-pass, my car started to float, and I pushed my foot on the

gas so I could speed up to get out of the water, which all of a sudden came from nowhere. When the truck and minivan went into the underpass, there was approximately one to two inches of water on the ground. Not an amount to be worried or concerned about driving through. I believe what happened was that when the two cars went into the underpass side by side, it pushed the water away from the ground and into the gutters, and then the water quickly came right back out again, causing about three to four feet of water to immediately cover the street.

As I pushed my foot on the gas pedal, my car started to slowly turn in the opposite direction. I immediately thought of the electrical system, so I turned the car off because my car started to sink under the water. I tried again and again to unlock the door, but it would not budge. By this time, my car was completely submerged, and all I could see was dark, murky water around me. It felt like being inside the ocean.

I then heard this unusual sound, and I wasn't sure where it was coming from. As I looked down, the water was seeping into the car through the door seals. It was slowly covering my feet, then my calves, and working its way up to my knees. I tried again and again to unlock the door and to open the handle, but nothing happened. At this point, I knew if something didn't happen, I was going to drown inside my car. I grabbed my purse from the back seat and dialed 911. As calmly as I could, I told them that my car was flooding and I was under the 610 Freeway and 59 Freeway at the Westpark exit. The 991 operator's response was, "Ma'am, if your car is flooding, you have to

call a tow truck." I frantically repeated myself and received the same response. In hindsight, I believe that I didn't say I was inside the car, nor did she ask.

By this time, the water was up to my waist and slowly working its way higher. It was only by the grace of God that I had the wherewithal to scroll down my phone and find the number for AAA. When AAA answered I, as calmly as I could, explained that I was locked inside my car underwater and my door couldn't open. The lady on the phone was very direct with me. She said, "Ma'am, listen carefully, or you are going to drown! Try again to open the door, and when it opens, wait a second because the water will come rushing in. After a second, when the water settles, try your best to get out and get to safety!"

By this time, the water level had risen between my chin and my bottom lip. I pressed the door lock button of my car. This time, it unlocked, and I opened the door. The water came rushing in. I held my breath for a few seconds and stepped out of the car. The water was still approximately four feet deep, and as I stood on solid ground, my head was fully out of the water and I was able to breathe.

I was still on the phone with the lady at AAA and told her I was fine. I knew I wasn't fine. I was in complete shock. I was soaking wet. I was numb. I was cold. I was scared. I was confused. But, I was safe! God bless that lady from AAA for being so direct with me. It gave me the courage to try to get out of the car. She was a gift from God! In that moment when the door opened, I witnessed God's touch.

As I was walking away from my car, there was a young man standing near the edge of the water, and on the other

side, there was a lady taking pictures of me with her cell phone. I walked toward the young man, and he just grabbed me and kept hugging me. I asked him if he was okay, but he just kept hugging me. Then a barrage of help appeared. The police, the tow truck, the fire department. The traffic was backed up and being diverted, and I was just standing there wet and confused. I saw the fire truck arrive and watched the firemen jump off and head toward the water. I said, "I'm the person who was in the car!"

The fireman anxiously questioned me, asking, "Is anyone else in the car?"

I said, "No, sir, it was just me."

He asked, "How did you get out of the car?"

I said, "I just opened the door."

"That's impossible," He then said, "Let me see your driver's license."

I handed him my driver's license, and he asked me several questions. I answered all the questions correctly. He said he would stand there for a few minutes to make sure I was okay. I explained to him that I walked out the door and that I didn't break any glass or anything like that, nor did I hit myself or my head coming out of the car, so I knew there was nothing internally wrong with me.

After the firemen left, the police allowed the tow truck to come closer to the area, but did not allow him to retrieve the car until the water receded. It took a little over an hour for the water to get low enough for the tow truck to retrieve my car, and then he took me home. The incident occurred literally one block from where I lived. When I got inside my home, I thought about the picture I

took the day before, and in the picture, the figure was coming out of the water, and there was a hand reaching down toward the water. It was literally twenty-four hours after the picture was taken that I was underwater, and I'm not certain if it was an angel or Jesus, but in my heart, I felt the presence of Jesus leading me out of the water without a scratch, bruise, bump, or broken bone on my body. It leaves me grateful, thankful, and speechless, and it humbled me to know that I received a miracle that day.

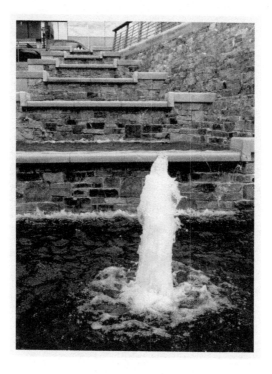

LESSON LEARNED: Not accomplishing all I want to do before I pass away does not concern me anymore, not whatsoever. I know now that I will not leave this physical earth one second before my appointed time and all that I am to accomplish will be completed.

7 YEARS (COMPLETION AND CONNECTION)

"But they that wait upon the Lord shall renew their strength;
they shall mount up with wings as eagles; they shall run, and
not be weary; and they shall walk, and not faint."
Isaiah 40:31

I n October 2017, I signed up to take a trip with New Life Ministries. The name of the trip was "In The Footsteps of Paul," and we were going to explore Greece and Turkey. What started out to be an ordinary journey turned into a life-changing experience beyond what I could have ever imagined.

October 21, 2017. In the back of my mind, I knew something amazing was going to happen, because twice that day, the number 18 showed up! We had just returned from Ephesus and were going to have lunch on the ship and then take a smaller boat and sail to Patmos later that

day. As soon as we returned to the ship, I went to my room and dropped off all my items and headed to lunch without my purse or cell phone. I was going to just have a quick lunch and then return to my room afterward for some journaling time before we headed off to Patmos. I walked down to the dining room, and just as I got in line, the head waiter asked me to step over to the left side because the right side was closed. I walked over to the left, and on my way there, a couple of ladies asked if they could join me for lunch, and I said yes. Again, as soon as we got to the door, the head waiter asked if we could go to the right side because the left side was full. So, we just politely moved over to the right side and all three of us were seated at Table 18. Holy Spirit! I didn't have my camera or anything with me, and I couldn't believe I couldn't take a picture!

After lunch, I returned to my room and started to read a bit about our next stop. I laughed when I saw the description of our next activity and 18 was mentioned. "Visit St. John's Monastery. Grotto of Apocalypse. In 95 A.D., John was sent into exile. He remained on the island for 18 months in a cave below, where we will see the Holy Grotto as well as priceless icons and manuscripts." I journaled for a few minutes, then I headed out to the boat. Once the boat docked, we were led toward our tour bus. As soon as I got on the bus, the tour guide started to hand out our Whispers. She handed me my Whisper, and I just looked, or rather stared, at mine and thought to myself, "Oh no!"

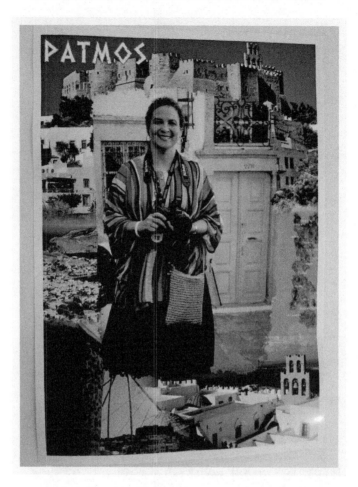

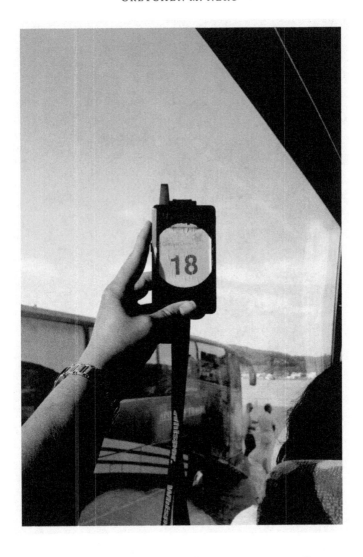

We arrived on the island of Patmos. Our small group toured the monastery and then went to the library to view some of the artifacts. As our tour guide was speaking, I had stepped away from the small group to look around. It

was really quiet in the area where I was standing, and I heard a voice saying, *"You are no longer responsible. It is finished. Your life is new."* I looked behind me, and there was no one there! There wasn't a person even in close proximity to me. I wasn't afraid because it sounded exactly like the voice that said, *"You are significant, and I'm going to make you anew."* The words shook me so much that when I got back onto the ship, I journaled my thoughts as to what I thought the words meant. I could not get those words out of my mind, but, even more importantly, the tone of strength in the voice that spoke the words. Of all the places in the world that the Holy Spirit chose to reveal this to me, this was the same location as where the Book of Revelations was written. My constant statement to my friends is "God has a great sense of humor!"

We continued on our journey, and three days later, we visited Meteora, Veria, Vergina, and Thessaloniki. It was late in the evening on October 24 when we arrived at our hotel. It was our first time checking into this hotel, so as soon as I arrived in my room, I called down to reception to get the Wi-Fi password. I connected right away and thanked the gentleman and hung up the phone. Immediately after I hung up, my hotel room phone rang. Thinking it was reception calling me back for some reason, I immediately picked up. It was my cousin Damien, who lives in Los Angeles, CA.

Me: Hello.

Damien: Hey, Gretch.

Me: Hey, Damien.

Damien: How are you?

Me: I'm fine, how are you?

Damien: I have some bad news to tell you.

Me: Okay. What's up?

Pause...

Pause...

Pause...

Damien: Your Mom passed away.

Me: Oh, I knew that.

Damien: What?

Me: Well, the Holy Spirit said to me three days ago, *"You are no longer responsible. It is finished. Your life is new."* I knew something significant was going to happen, so I journaled what I thought. The bellman should be here in about twenty minutes, and my journal is in my luggage. We'll talk until my luggage arrives, and then I'll read you what I wrote.

Damien: Okay.

Damien and I continued to talk, and he explained that my Mom had a heart attack, and that although she was rushed to the hospital, she never regained consciousness. About fifteen minutes later, the bellman knocked on the door, and I retrieved my journal out of my luggage. I read to Damien what I had written three days prior. His response was, "Wow."

I didn't immediately leave Greece since my Mom had already passed, but started to plan her home-going celebration in the evenings following our daily tours. Since it was a long flight from Athens to Philadelphia, I decided to prepare the speech that I was going to make during the Ceremony.

Speech:

About a year ago, my Mom asked if I ever thought about becoming a preacher, and I said, "Absolutely not!" I told her that you do not have to be a preacher to spread the love of Jesus.

So, in honor of my Mom, I am going to do a small sermon. I'm going to read directly from the paper since I don't want to miss any of the details. The name of this sermon is *"God is in the Details!"*

About five years ago, I moved to Houston for my job and had not been back to Los Angeles in four years. I planned on visiting in August, and I thought the best way to see all my friends and family would be to give a party. Since it was in August, it quickly turned into a birthday party since my birthday is in August.

I had selected the color of the napkins for the table in a sky blue. Sky blue was literally the color of Heaven to me... *Details!* I had selected a dove, which is the symbol for the Holy Spirit for the goodie bags... *Details!* Of course, I was absolutely not thinking of the significance of the *Details* at that time!

God knows our sunrise date and our sunset date and all of the *details* of our lives in between. I believe God was preparing my Mom for her transition, and God knew my Mom would not be here to celebrate her "Big 80" birthday.

So you see, it was really my *Mom's* party! The reason I know this really was her party is because while I was paying attention to all the *details*, my Mom had an oppor-

tunity to eat, drink, dance, laugh, and socialize with her friends and family.

My cousin Kristen sent me a text message saying, *Thank you Auntie Gretchen for giving your party. If it wasn't for your party, lots of people would not have seen her in a while.*

Thank you, Kris. That message was VERY comforting!

Now see, Damien is focused, calm-natured, and cool. He advised me of the news about my mom. On the other hand, I received a text from my cousin Kenneth who just wanted to hear my voice. I called Kenneth, and he was crying so hard that *I* had to calm him down! "Kenneth, Kenneth, Kenneth, *calm down*, man, you are no good at this! Aren't you supposed to be comforting me?" God was even in the *details* of sending the correct person to call me.

Being in Greece on a spiritual journey really let me know that God was in the *details*. He knew I couldn't handle this immediately, and He graced me with time to process, pray, listen, and be still.

Before my Mom's spirit left her physical body in her last couple of months on earth, she was able to attend her family reunion, have shrimp and grits in Houston with me, go to Galveston with her sister Bea, and visit the Catholic Painted Churches in Schulenburg, TX, and party like a rock star at *her* party, and now we are here celebrating her home-going all because God was in the *details*!

End of speech

What happened during the planning of my Mom's funeral really made me realize how our loved ones are

closer than we think, and they watch over us and help guide us.

When I arrived back in Los Angeles, I had an appointment with Craig at Lighthouse Memorial in Torrance, CA, and my Mom's sister, Aunt Bea, came along with me. During the appointment, Craig asked that I take a look at the themes to go on the cover of the guest book and thank-you cards that I wanted to purchase. We were sitting in a large conference room going over the details for the funeral, and the different themes were on a wall across the room from where we were sitting.

Aunt Bea and I got up to look at the selections. On each ledge were four different samples, from a note card, a thank-you card, the cover for the obituary, and the cover for the guest book. There were several different themes, such as veterans, American flag, beach, flower scene, and the very last sample we looked at was the Blessed Virgin Mary. I sort of laughed and told my aunt, "Of course it has to be the Blessed Virgin Mary!" My Mom was Catholic, and I just knew that was what she would have wanted. My aunt and I sat back down, and I told Craig my selection, and we continued with the meeting.

About ten minutes later, we were right in the middle of our conversation when all of a sudden, a rush of wind came in the room, and three of the four items with the beach scene fell off the shelf. Craig, my aunt, and I just about freaked out because it just came out of nowhere. Craig turned around and just stared at the shelf. I immediately said, "We didn't touch a thing!" There was no need

to touch the different items as we were deciding which one to select. My aunt and I got up from the table and walked across the room to place the items back on the shelf. Although we continued the meeting, it was awkward because we really didn't understand what had just happened. Toward the end of the meeting, Craig had asked me for my Mom's undergarments, which I had completely forgotten to bring to the meeting. I told him I would bring them the following morning.

The next day, I was literally down the street from the funeral home and fell out crying because something came to my mind. I called my cousin Karen at work and said to her, "What is the one phrase my Mom *always* says when she meets somebody new?" Karen couldn't immediately think of the phrase, but when I said, "I live at the beach," she said, "Oh yeah, that's right!"

When I arrived at the funeral home, I went directly to the front desk and said, "I need to change the cover for the guest book." We went from the Blessed Virgin Mary to the beach scene because I sincerely think my Mom's spirit was making its presence known. I know my Mom's presence was present in that moment.

Since everything was now arranged for the home-going celebration, I decided to start cleaning my Mom's apartment. I sat in the middle of the floor with three black garbage bags. One for donating, one for trash, and one for items to give away to friends.

The moment I sat down on the floor to start cleaning; my eyes were drawn to a black leather folder on a shelf across the room. I got up and walked over, picked up the

leather folder, and sat back down. As I opened the folder, I could clearly see that my Mom had gone to a luncheon because there was a pen, writing paper, menu, and reading matter. I was clearing out each pouch and throwing the items away so I could just donate the folder. When I reached in the last pouch, I pulled out my Mom's passport. I spoke aloud to her, saying, "Mom, why is your passport in here? You would have never found it!" I looked at her passport and started to read all the information, and something didn't make sense to me. I read it again and again and again before I literally dropped the passport and burst out crying. My mom's journey on earth had really ended. It was finished! It was written! It was the final *detail* of her life! My Mom passed away on October 24, 2017, and her passport expired on October 24, 2017!

My Mom. Our relationship was complicated. About four years before she passed away, she apologized to me for the things she did and did not do for me when I was a child. I could clearly see that she was trying to have a healthy relationship with me, but there was something that wasn't going to allow her to fully be happy and enjoy her life. There was a secret.

It was in 2015, May 31, to be exact, that we were having brunch after going to Lakewood Church, and I started asking my Mom where my brother was. I didn't know if he had been adopted, but I've always known I had a brother. My Mom looked at me as if she'd seen a ghost when I spoke those words to her. She asked me how I had known about my brother, and I told her I had always

known I had a brother, but no one ever told me where he was or talked about him.

Growing up in the 1960s, it was understood that kids were to be "seen but not heard." My Mom went on to tell me that she had an abortion about two years before I was born, and the child was so far developed that she could tell it was a boy. She named him Anthony, and that's why she prayed to St. Anthony all the time.

I said to her, "Mom, you know that God forgave you, right?"

Her response was, "No, He didn't."

I said to her, "Why would you say that?"

Her response was, "Because He never gave me any more kids."

I said to her, "What about me?"

Her response was, "Oh, I'm not taking about you."

I decided not to continue the conversation because at this point, she was crying so hard right there in the middle of the restaurant, and I didn't want to cause her any more pain.

The next day, when I got home from work, my Mom had written me a card and purchased me a vase of sunflowers and a rose. Her words were something that I will treasure forever.

"Thank you for lunch yesterday. I have been praying for both of us. Asking God to send an angel to me. God does answer prayers. He sent you my angel. Yesterday when you brought up your brother, I was not shocked – but relieved. I pray for us each day. Putting God first in my life has made me strong. Love you. Take care of YOU.

Your Mother."

The best reward of her being able to tell the truth and not be judged was the feeling that she was literally set free and truly believed now that God had forgiven her for the abortion. What breaks my heart into a billion pieces is that I know God forgave her the moment she asked for forgiveness. It was my Mom who carried guilt, shame, and unforgiveness for herself and never felt worthy of being able to truly enjoy her life and receive all the good gifts that God had planned for her for over sixty years for a mistake she made as a teenager.

Absolutely heartbreaking! Do I believe that abortion is wrong? Yes. Do I believe that God forgives you? Yes! If I had known years ago, I would have told my Mom that I have proof that God forgave her. She probably would have asked me how I had proof, and I would have told her, "I have proof because God trusted you enough to give you another chance to raise a child." I believe those words would have made a huge difference in her life.

My Mom was really beautiful, kind, smart, funny, an extremely talented seamstress, brave enough to start her sewing business right out of high school in Lake Charles, LA, a risk-taker by leaving Louisiana as a single parent with her two sisters and their families to go to California for a better life. She loved to dance, loved music, loved children, loved to laugh. She loved to cook and loved her Cadillac margaritas. She always dressed with style and boldness. She loved to travel. She loved being a Eucharistic minister. She loved St. Agatha's Catholic Church in Los Angeles, CA, and St. James Catholic

Church in Redondo Beach, CA. She loved her daughter and loved BINGO!

When I returned to Houston, TX, after the funeral, I found myself *very* sad because I had not been married yet and my Mom is no longer with me, and for her entire career, she made wedding dresses. How sad that my Mom will not get to attend my wedding or make my wedding dress. It also was the month before Christmas, and I realized she wouldn't be here to send me a Christmas present. To make myself feel better, I decided to order some shoes from Zappos. Both she and I *love* shoes! I was going to wrap them up and "act surprised" for Christmas so I wouldn't feel so sad.

Shortly after I ordered my "five pairs of shoes," every time I logged into my AOL mail account, which is where I ordered the Zappos shoes from, there was a box to the upper right of my screen that popped up and said *You*

might also like these. I didn't understand why Zappos would think I might like "these," because I've *never* purchased a pair of yellow shoes in my life, nor did any of the shoes I ordered resemble yellow. The five pairs of shoes I ordered were all darker colors.

A couple of days later, I logged on to AOL mail again, and those same shoes popped up. I was looking at the shoes and I clearly heard a voice say, *"You're going to wear these on your wedding day."* I just about fell out laughing. I thought to myself, "Who wears *yellow* shoes on their wedding day?"

I started seriously thinking about what was going on, and it came to me.

I ordered the shoes, and when I received them and looked at the box, in *big bold numbers* it said: **8818**.

My favorite number is 8

My spiritual number is 18

My Mom's name was Catherine

Her favorite color is yellow

Her life's occupation was a seamstress (and her focus was bridal gowns).

The heels are even made out of spools of thread!

I will wear them on my wedding day as a way to honor my Mom.

I was talking to Mom Bobo and telling her the story about the shoes and saying that "Yellow is my Mom's favorite color and she was a Seamstress..." and then I thought of something. I grabbed my cell phone and googled, "What is Katy Perry's real name?"

Google replied, "Katy Perry's real name is Katheryn Elizabeth Hudson." Katheryn is spelled differently from

my Mom's name (Catherine), but it's still Catherine. This is downright amazing to me!

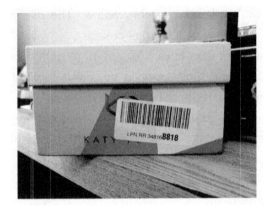

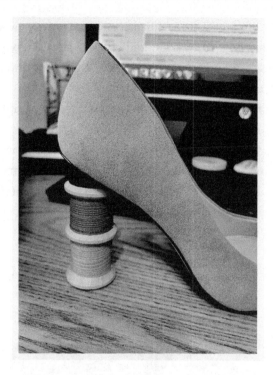

As I think back to the time when I first told Sharon in October 2010 that I needed to go to the Holy Land, it was literally "7 Years" (7 is the number of Completion) to the day when my journey was completed in Patmos, Greece in October 2017.

"You are significant and I'm going to make you anew" to *"Your life is new."*

The connection I feel to the Holy Spirit, because of Jesus Christ our Lord and Savior, is a beautiful, adventurous, joyous gift that has changed the trajectory of my life and has shown me the grace and goodness of God! The lesson I've learned is that I now fully lean on the Lord and wait for direction. Patience is something I did not have

early in life, but waiting for direction in my life now has taught me how to be calm and still. It also has given me the knowledge and the confidence that I lack nothing, nor have I missed anything in my life.

During a very difficult time in my life, the scripture I clung to was Isaiah 40:31 " But they that wait upon the Lord shall renew their strength; they shall mount up with wings as eagles; they shall run, and not be weary; and they shall walk, and not faint." I am extremely grateful to have my strength back! My life is still unfolding before me, and I'm excited about the new journey ahead.

LESSON LEARNED: When you lose all your strength after something tragic has happened in your life, just wait and be still. You will regain your strength!

MY PRAYER FOR YOU

W riting this book has been a journey of complete healing and restoration for me, and my prayer for you is that I hope this book will help to reignite your faith, if it has lessened for any reason.

I pray for you to become curious as to how you can personally connect with our Lord and Savior Jesus Christ. Possibly through a photograph, a song, a special number, words, walking along the ocean, walking through the woods, or just being still in His presence.

My prayer is also for you to forgive yourself just as you forgive others, because I know if you had known better at the time, you would have done better. No sense of going backwards, because God is a forward God! My most sincere prayer is that you have fun along the way! Jesus has a *great* sense of humor!

GRETCHEN NERO

Gretchen Nero was born in Louisiana, raised in California, born again in Israel and now lives in Texas. She's been an Executive Secretary for over 35 years and is now a first-time Author! She loves cooking, photography, reading, traveling, studying her Bible and continues to be inspired by the direction of Holy Spirit!

PAYING IT FORWARD

- Care for each other!
- Share **My Awesome Adventure With the Holy Spirit** with others.
- Leave a review online wherever you bought this book.
- Post the book and buy links on your social media so others find the help they need.
- Be the incredible human being God created you to be!

ACKNOWLEDGMENTS

This book is dedicated to my loved ones, both past and present, who have helped me to grow, to learn, to cry, to laugh, to be a student, to be a teacher at times, who saw me when I didn't see myself, I LOVE YOU IMMENSELY!!!

Jamie Attansaio
Sedie Avakean
Mattie Burnett Bobo
Dr. Guldal Caba
Letha Chavis-Boutte
Sheri and Richard Bright
Monica Chiapa
Amarjeet Chopra
Ekta Chopra
Dr. Henry Cloud
Dr. Marie-Madeleine Ekani
Joyce Fortune
Michael J. Fourticq, Sr.

DeAndrea Gallow

Susan Giles

James Grey

Darlene Hicock

Delores Hill

Janice L. Johnson

Laura Johnson

Wilanna Landry

Pamela Lewis

Valencia Madison

Mataeo Mingo

Myrna Moore

Dianne Nelson

Bernard "Uncle" Nero, Sr.

Pascale and Lorenia Nero

Jade B. Payton

Kristen L. Payton

Andrea Rawitt

Bueanka Scott

Leah and Scott Silverii

Larry and Rhonda Sonnenburg

Sunita Tarkunde

Jacinta Thompson

Julianna Williams

Joyce Wright

More titles from
Five Stones Press

fivestonespress.org

Made in the USA
Las Vegas, NV
18 November 2021

34768043R00049